FAT PETs

FAT PETs

Professor J.D. Scoffbowl

FOURTH ESTATE · London

First published in Great Britain in 2008 by
Fourth Estate
An imprint of HarperCollinsPublishers
77–85 Fulham Palace Road
London W6 8JB
www.4thestate.co.uk

Visit our authors' blog: www.fifthestate.co.uk

9 8 7 6 5 4 3 2 1

A catalogue record for this book is available from the British Library

HB ISBN 978-0-00-729269-1

Typeset by 'OMEDESIGN
Printed in Italy by L.E.G.O. SpA - Vicenza

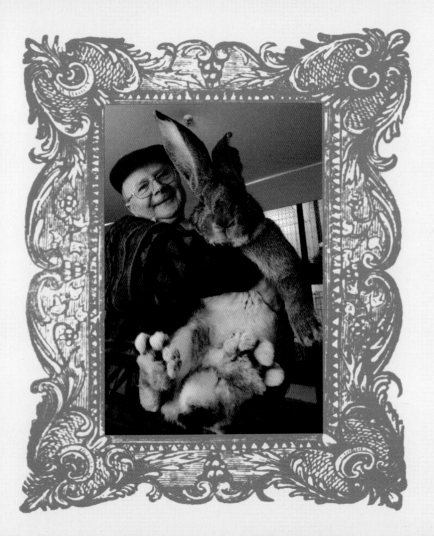

*H*ercules the cat was in the habit of sneaking into a garage owned by Jadwiga Drozdek, who left food there for her own six cats. Hercules would guzzle their food until one day he'd become so fat he got wedged fast in the catflap. Jadwiga – who had seen him in the garage before but not, until then, managed to catch him – took 20lb Hercules, who seemed to be a stray, to an animal sanctuary.

HERCULES

HERCULES

the Cat

➡→

*The story of Hercules's criminal
exploits and eventual capture made
the television news.*

The story of Hercules's criminal exploits and eventual capture made the television news. Geoff Earnest saw the story – and recognised Hercules as his own cat, who had gone missing six months previously. Geoff – who has cystic fibrosis, a genetic disorder that leads to breathing problems – had adopted Hercules four years before.

HERCULES

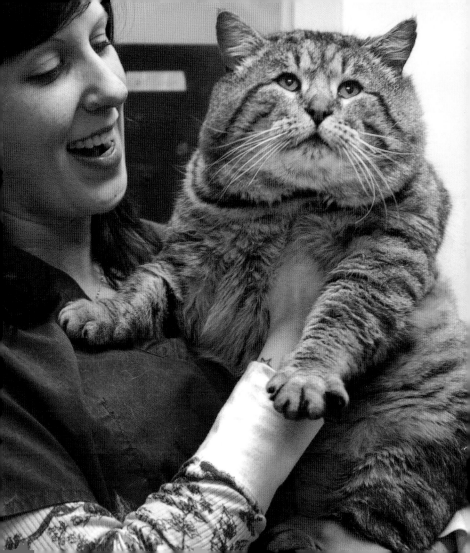

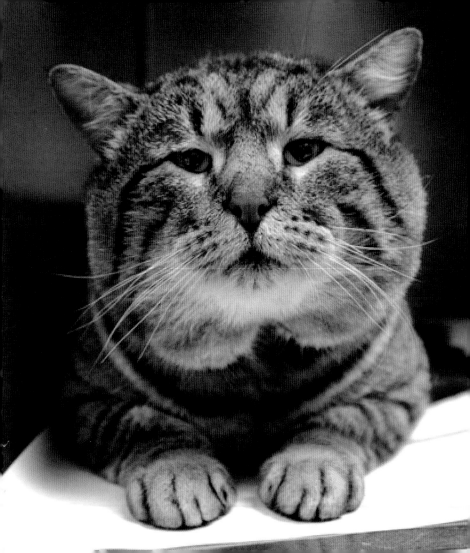

As Geoff's illness had got worse, Hercules would lie on his stomach and play with his oxygen tubes. But until Hercules appeared on the news, Geoff hadn't seen him since he went into hospital for a lung transplant and had left Hercules to be looked after by a house-sitter. Hercules had somehow made a journey from the American city of Portland, where Geoff lives, to neighbouring Gresham, where Jadwiga lives. After Hercules got stuck in the catflap, he and Geoff were reunited at the animal sanctuary – and that story made the news too.

HERCULES

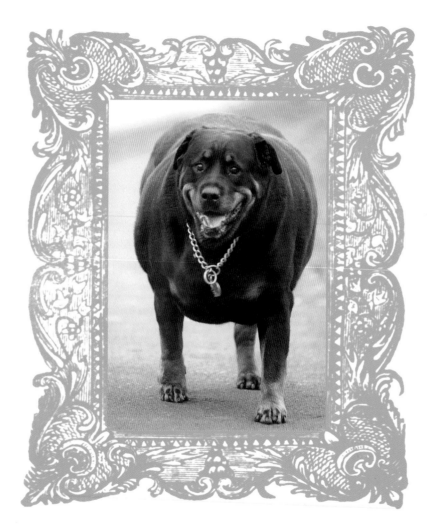

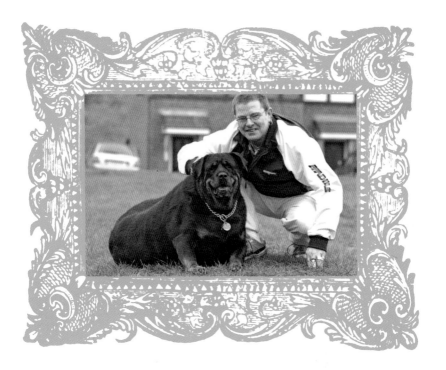

BeauDelle Princess

the Rottweiler

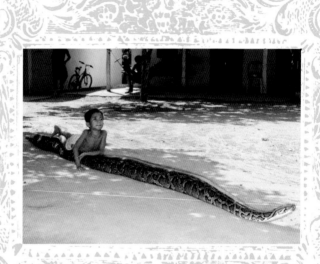

CHaMReUN

the Python

Sambath Uon, a boy from the village of Sit Tbow in Cambodia, formed an unlikely friendship with Chamreun, a six-metre-long, 265lb female python. The snake first arrived at Sambath's house when the boy was three months old, and continued to stick around even though Sambath's father carried the snake into the forest and left him there three times. Sambath and Chamreun, say villagers, have slept together since Sambath was a baby. The villagers believe that Chamreun – whose name means lucky in the Khmer language – has healing powers.

CHAMREUN

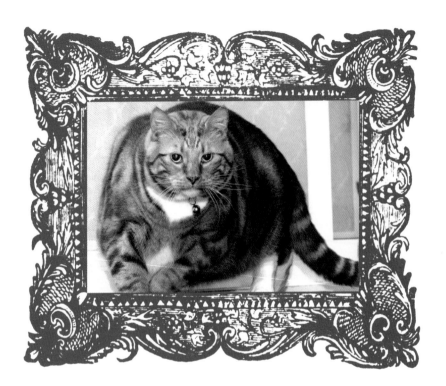

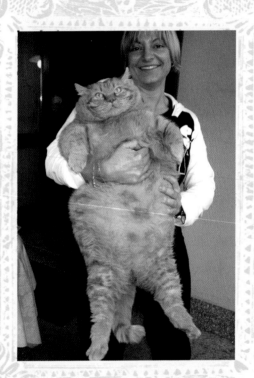

ORAZIO

ORAZIO

the Cat

Who ate all the lasagne? Orazio the 35lb cat hails from Eupilio in Italy. Here his owner, Laura Santarelli, is risking a serious hernia by lifting him.

KELL

the Dog

Kell – a massive English mastiff – was, in 1999, named the heaviest dog in the world, weighing in at 21 stone. 'Some people are convinced she must be fat,' said her owner, Tom Scott. 'But she is happy and healthy and I've a vet's certificate to say she is not overweight at all. When we go to shows, she is so big I have trouble getting her into our van.'

KELL

Sassy the cat became world-famous after his picture appeared on the internet – prompting some to label the pictures a hoax. But Sassy was real – and lived in the Canadian city of Ottawa.

SASSY

SASSY

the Cat

SASSY

His owner, Susan Martin, said that in 2001 Sassy weighed 40lb – and she's mystified as to why he ended up so much bigger than her other cats. 'He was on diet food for about eight years,' said Susan, 'he did not eat an excess amount of food and did not eat table scraps – he was well loved and cared for. We had another cat that ate the same food and he didn't get fat.'

SASSY

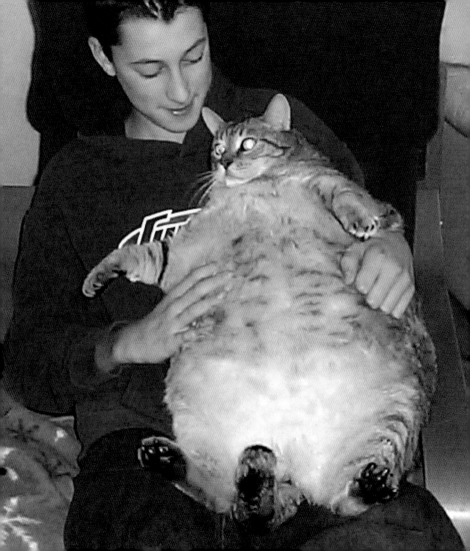

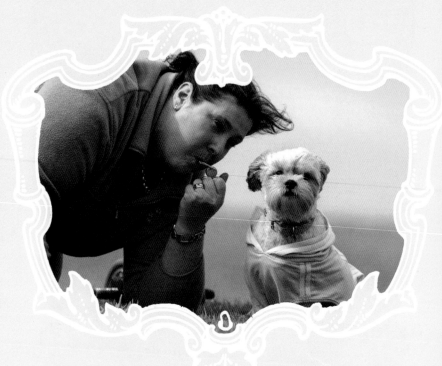

TESS

TESS

the Dog

*T*ess the dog is encouraged to do some weight-losing exercises – wearing a specially designed tracksuit for dogs.

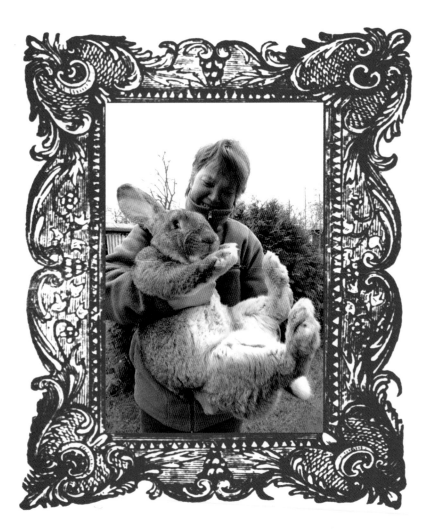

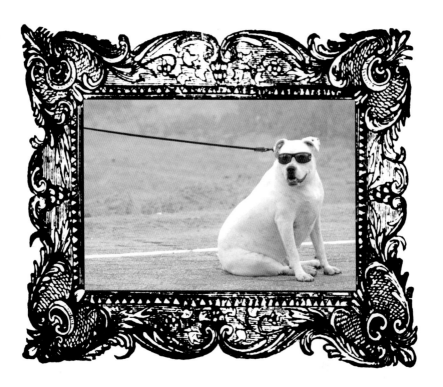

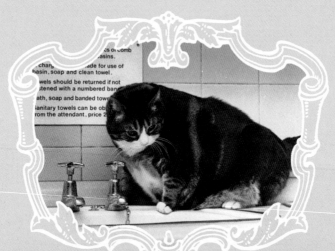

TIDDLES

the Cat

*T*iddles was one of the most famous felines ever to have existed – and also one of the fattest. He lived most of his 13 years in the ladies' lavatory at London's Paddington Station, where rail passengers brought him titbits. So much food was left for Tiddles that station staff provided him with his own fridge – and after he appeared in several national newspapers, parcels of food arrived for him, addressed to 'Tiddles, Paddington Station'.

TIDDLES

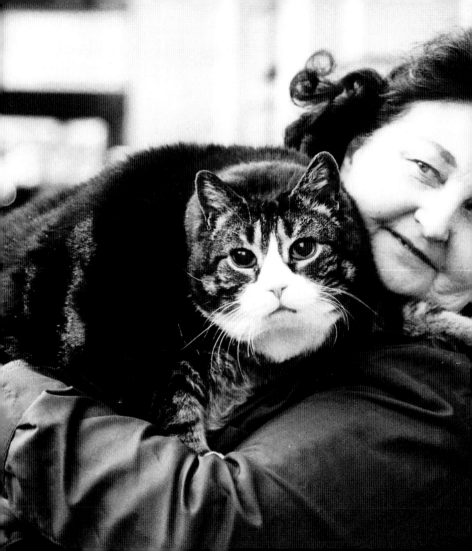

After winning a contest to find London's fattest cat in 1982, Tiddles eventually reached the weight of 32lb – the average weight of a three-year-old boy. He breathed his last not long afterwards.

TIDDLES

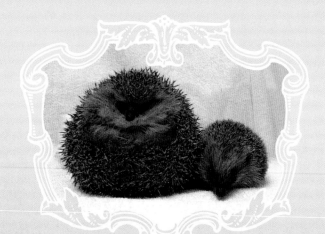

GEORGE

the Hedgehog

When George the hedgehog arrived at a wildlife sanctuary, he weighed an astonishing 5lb – nearly four times what he should. The owner of a garden where George was found had handed him in because he thought he might be ill. However, it turned out George was simply overweight – what you might call a porky-pine.

GEORGE

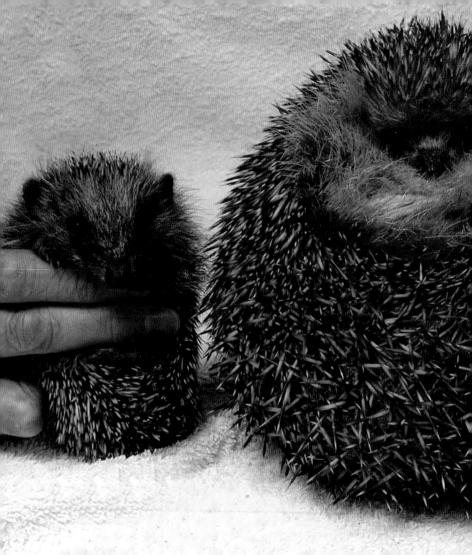

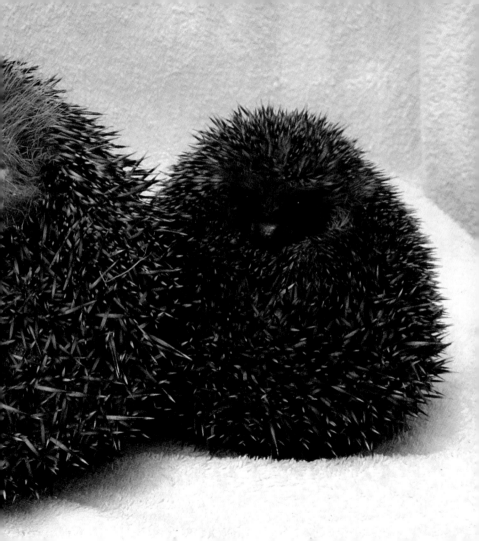

Sara Cowen, an animal nurse, explained: 'At first we thought he had a condition called ballooning – where air gets trapped under the skin – but when he was brought in, we realised he was just a huge fat hedgehog. He's the size of a football.' George had gained weight by gorging on bread which had been left out for birds. Staff at the Wildlife Aid Centre in Surrey put George on a diet of cat food, hoping to get him down to his ideal weight of 1lb 5oz.

GEORGE

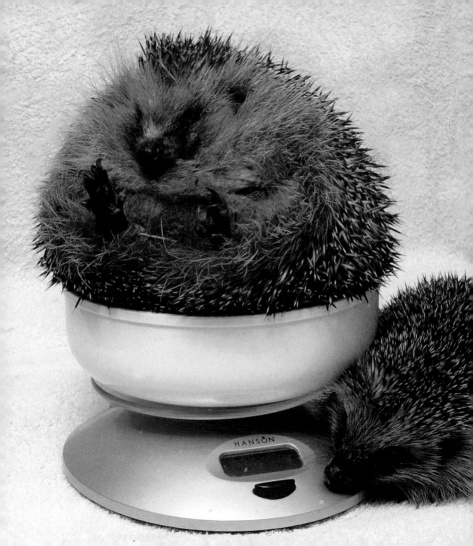

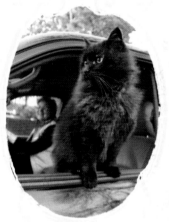

Sergeant

PODGE

the Cat

*S*trictly speaking, Sergeant Podge isn't fat, but he is both very lazy and exceptionally ingenious. Each night around dinner time, he leaves the house where he lives in Bournemouth – and the next morning he is always found by his owner, Liz Bullard, waiting by the roadside at the same spot, a mile and a half away. Then Sergeant Podge climbs into Mrs Bullard's Toyota Land Cruiser, and she drives him home.

Sergeant
PODGE

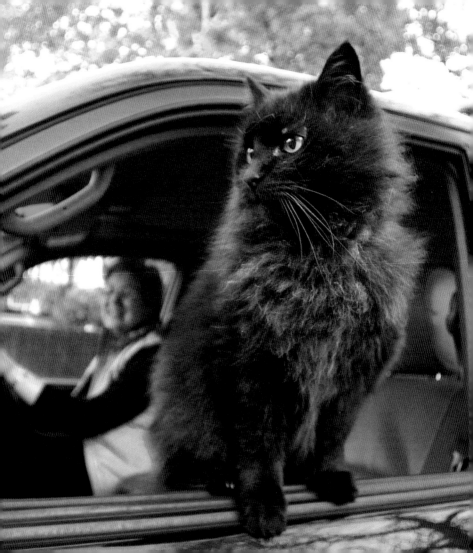

No one knows why Sergeant Podge makes his nightly journey – or why he prefers to be driven home. Mrs Bullard suspects someone else is feeding him, near to where he is picked up, but said: 'It's not as if he goes starving, he gets eight sachets of food a day here, and tuna.' When Mrs Bullard and her husband are on holiday, a neighbour picks up Sergeant Podge from his usual spot.

Sergeant
PoDGE

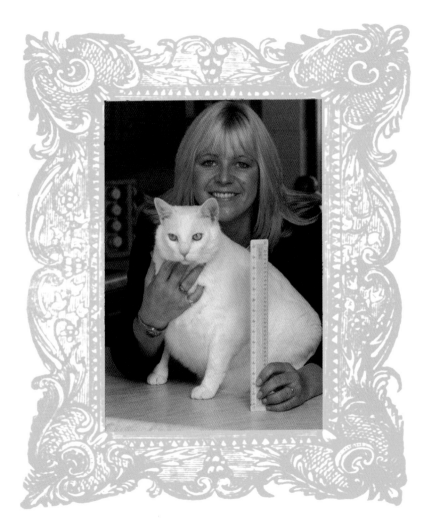

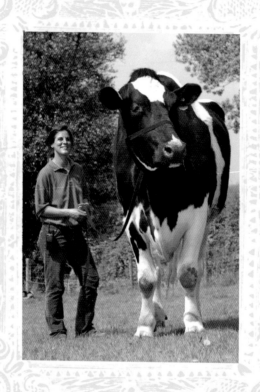

CHILLI

CHILLI

the Cow

In the spring of 2008, Chilli, a giant Friesian bullock, was found to be one of Britain's biggest cows. At nine years old and well over a ton, he stands six feet six inches tall.

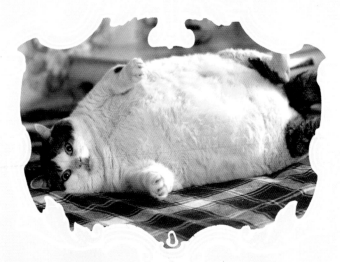

CHINESE

Cat

*T*his Chinese cat, from Shandong Province, weighs 37lb and has a 34-inch waist – as wide as the waist of an average British woman. Its owner, Xu Jirong, said that he has tried putting the cat on a diet but it then gets very annoyed – scratching visitors and peeing all over his house in protest. The cat's usual diet is dough rolls and chicken hearts – and it likes to sleep on its back.

CHINESE

Pictured here pausing between snacks, this cat is thought to be the largest ever recorded in China.

CHINESE

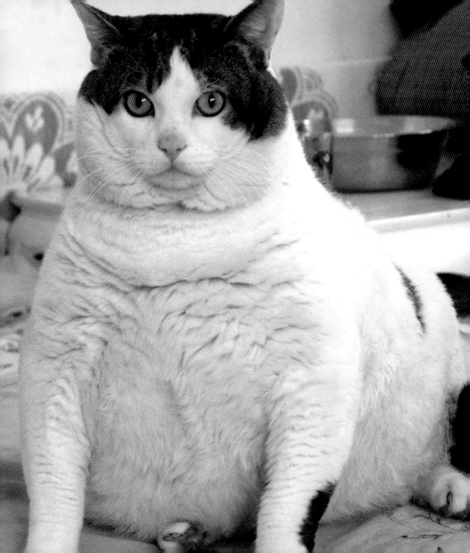

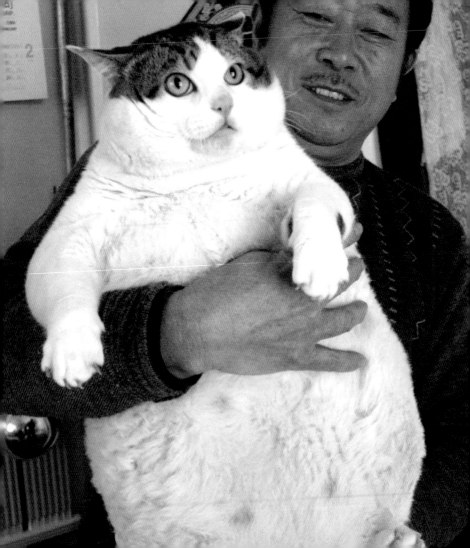

CHINESE

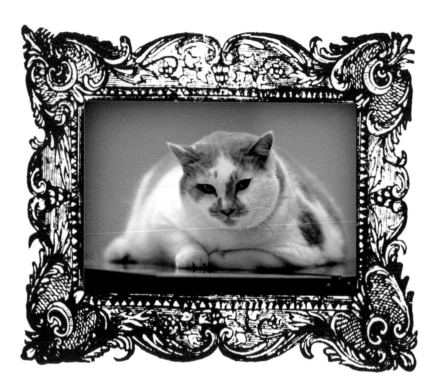

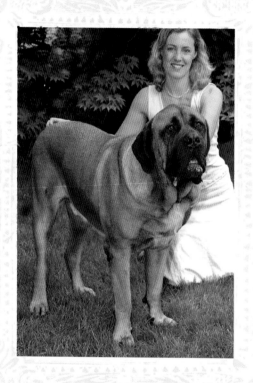

BORIS

BORIS

the Dog

Boris the gigantic mastiff found fame when newspapers reported he could be seen from space – as he's visible lying in his front garden on the Google Earth. In fact, it emerged that the photos were probably taken from a plane – not from a satellite – but Boris is still a big old mutt.

➥

*Boris can be seen lounging on
his front lawn.*

BORIS

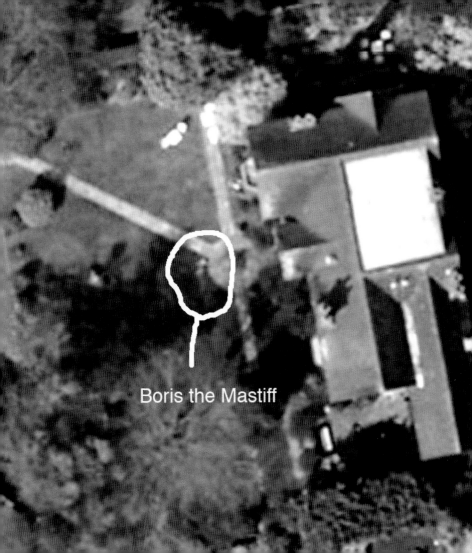

Boris the Mastiff

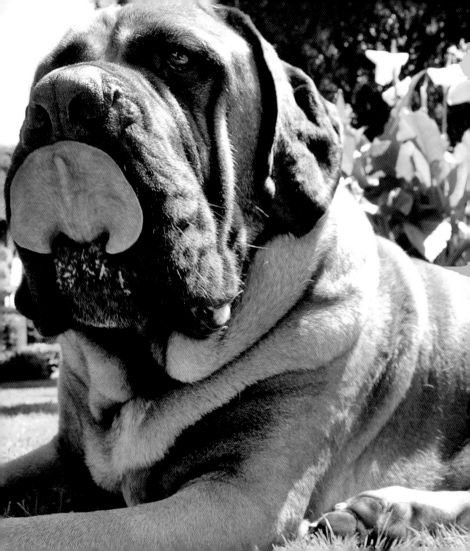

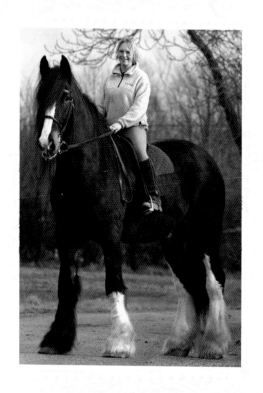

CRICKET
CRACKER

CRICKET CRACKER

the Horse

C ricket Cracker, a shire horse from Lincolnshire, was in 2008 found to be the tallest horse in the world – standing six feet five inches high.

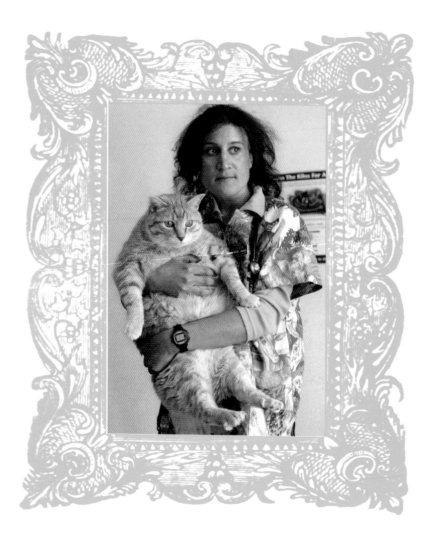

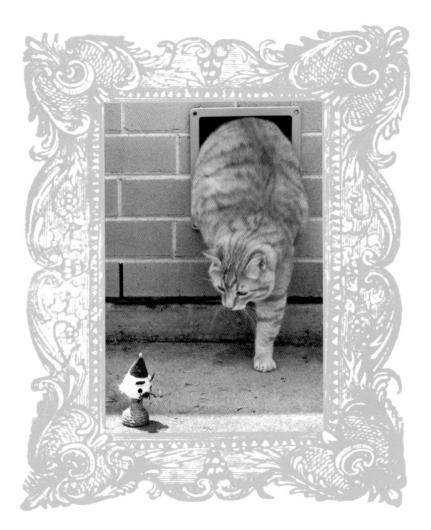

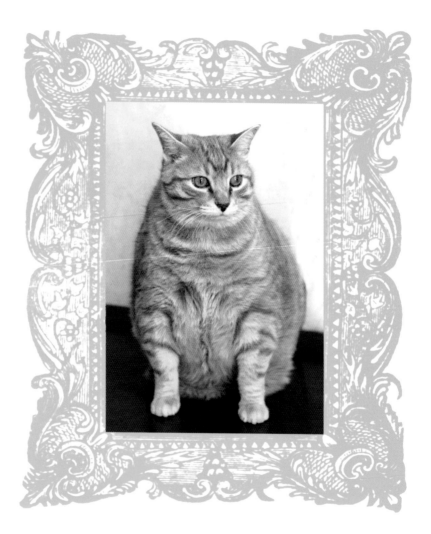

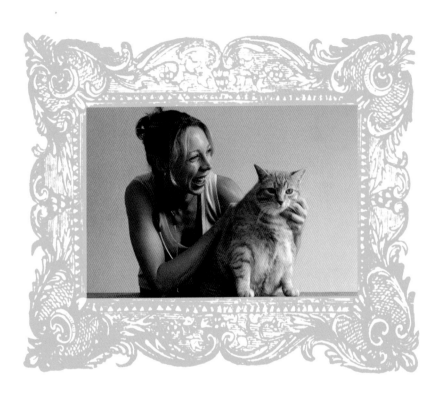

PRINCESS CHUNK

the Cat

This whopping great mog was found wandering the streets of New Jersey in July 2008 and taken into a shelter – where staff dubbed her Princess Chunk. Her owner eventually came forward – and revealed that she had lost her house and was no longer able to take care of the 22lb cat.

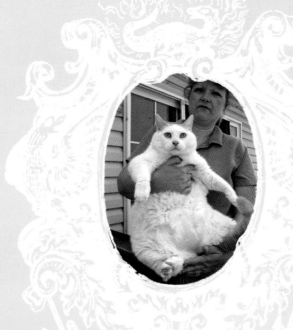

PRINCESS
CHUNK

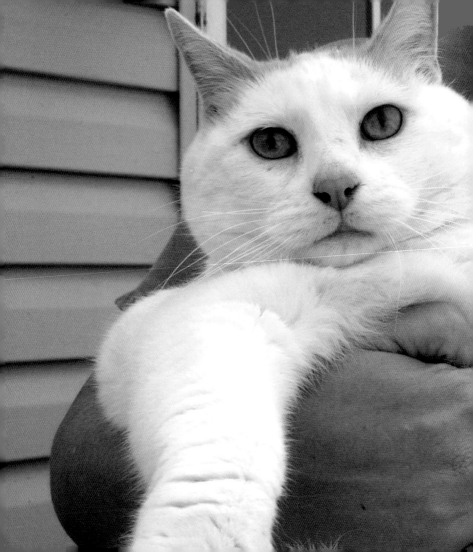

It also turned out Princess Chunk was a he and was originally called Powder. Luckily over 400 people volunteered to take care of Princess Chunk / Powder, and he now has a comfortable new home.

PRINCESS
CHUNK

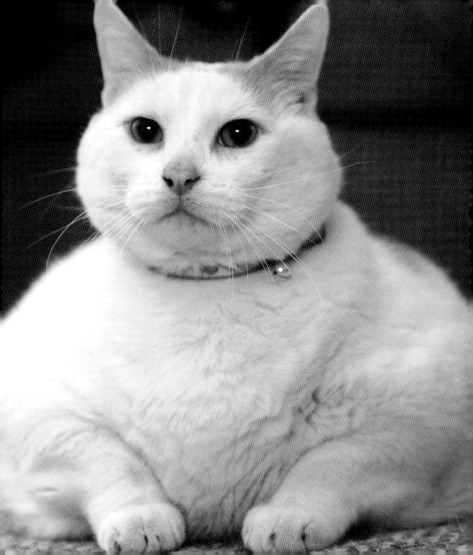

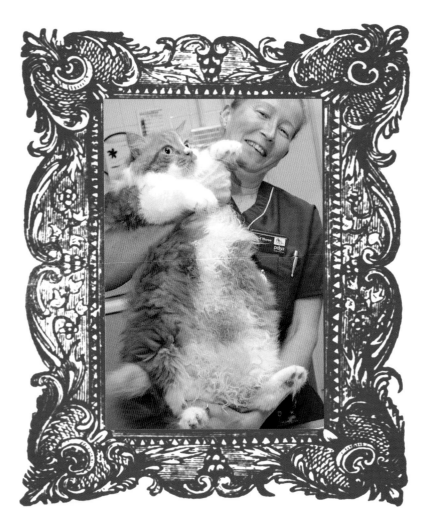

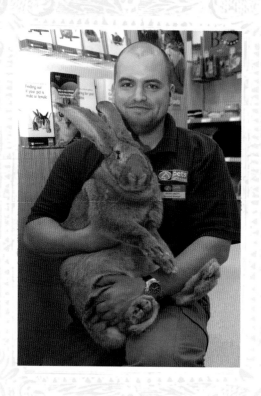

ROO

ROO

the Rabbit

15 lb Roo, a rare European giant rabbit, struggled to find a home because she kept munching through her owners' woodwork.

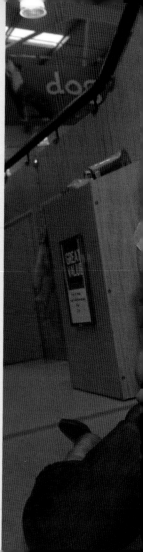

Roo is a surprisingly large rabbit.

ROO

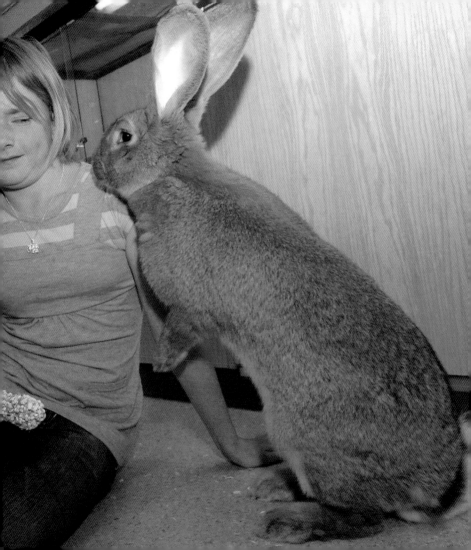

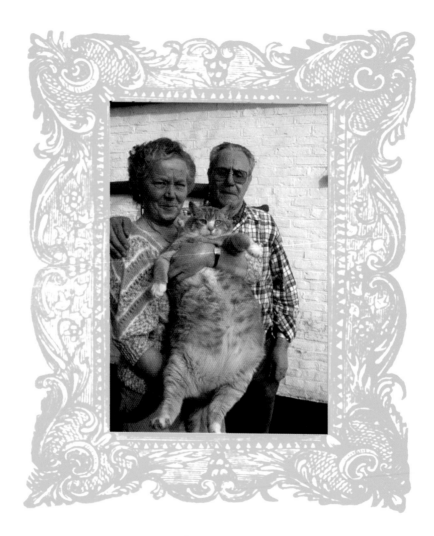

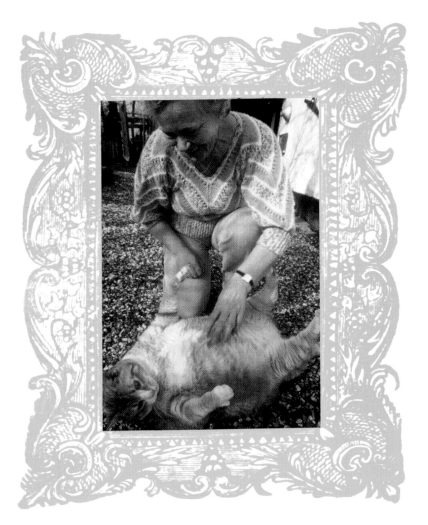

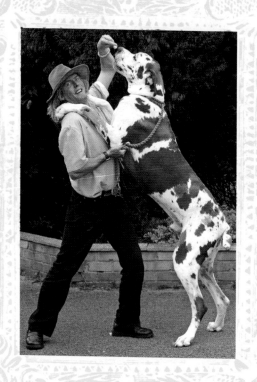

TiNY

TiNY

the Great Dane

*A*t over 7ft long, Tiny has been named the tallest dog in the UK.

Tiny – not, in fact, very tiny at all!

TiNY

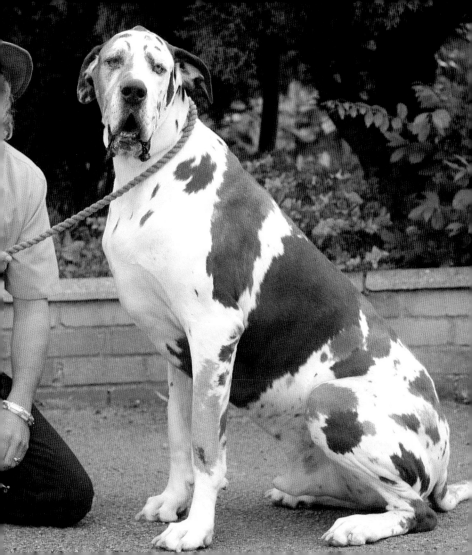

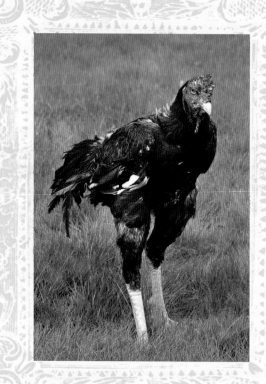

GINGER

GINGER

the Cockrel

Ginger, a rare Shamo cockerel, is 32 inches tall and a contender for the title of biggest chicken in Britain. He weighs 13lb. Shamos were originally bred as fighting cocks in their native Japan.

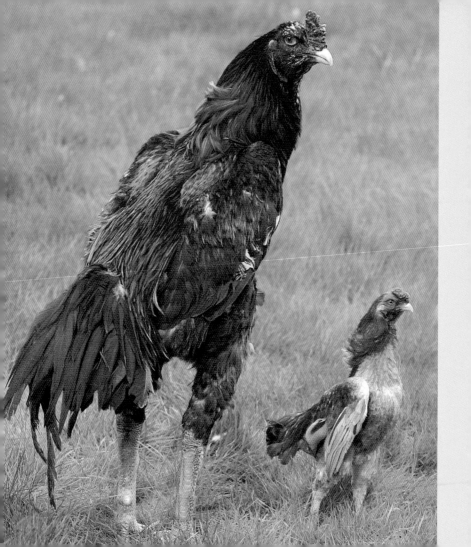

◄◄

*At 32 inches tall, Ginger could be
the biggest chicken in Britain.*

GINGER

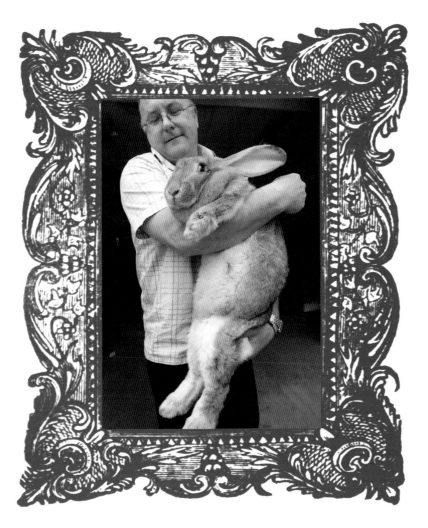

TOMMY

the Cat

*T*his picture was taken of Kathleen Cameron, a sweet-shop owner, and her pet cat Tommy, in 1981. Weighing in at 23lb and with a 25-inch waist-line, it's not hard to imagine Tommy getting stuck into a few Lion Bars.

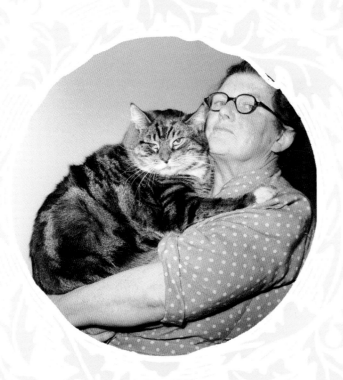

TOMMY

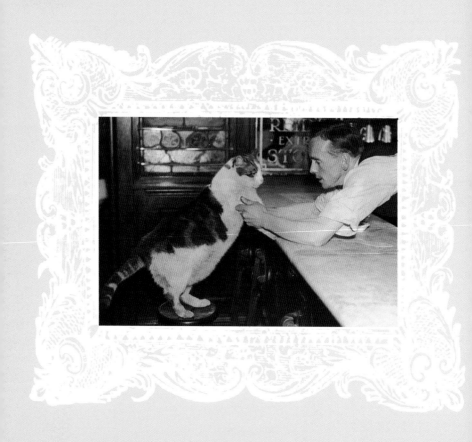

GINGER

GINGER

the Cat

Archives record that in 1935 Ginger was declared to be the heaviest cat in London – at 23lb. Here he is, at the Holborn restaurant where he lived, first in the queue for lunch and eyeing up the pork scratchings.

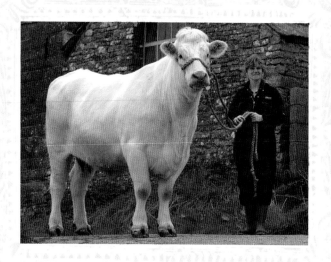

RIO

RIO

the Cow

At 11 feet long and weighing 1.25 tons, Rio, a pedigree Charolais cow from Dorset, was named in 2008 as possibly the biggest cow in the world. Rio weighs the same as an adult rhinoceros.

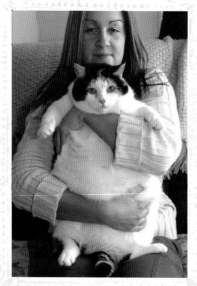

HONEY

the Cat

*H*oney the cat got so enormous that she couldn't fit through an ordinary catflap – instead she wiggled through a bigger, dog-sized hole cut in the door. In 2006 her owner, Linda Morano, declared that Honey, at three stone, must be the biggest cat in Britain.

'Honey doesn't eat a lot,' said Linda's 22-year-old daughter Ashley, 'she shares a tin of cat food a day with our other cat, Penny, yet she's twice the size of her … she is not being fed by neighbours or anything like that because she hardly goes out … it's a bit of a mystery.'

The Moranos said that during regular visits to the vet, Honey's heart was found to be healthy, despite her vast weight.

HONEY

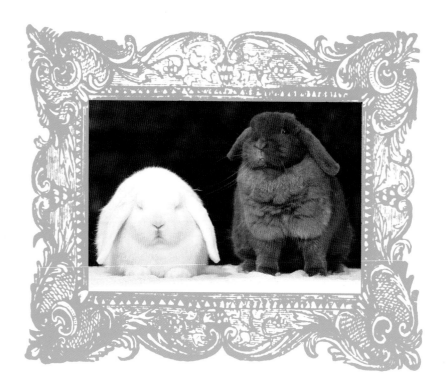

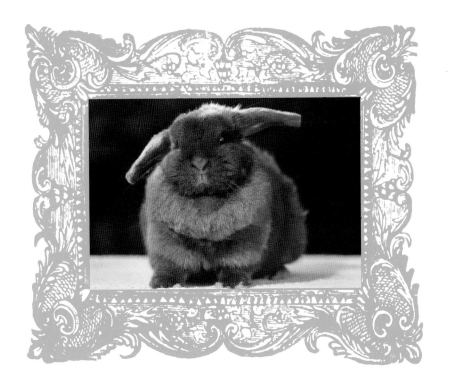

FIDGET

the Cat

Fidget the cat weighed 22lb, and even after a diet – when this picture was taken – notched up a hefty 18lb. Could Fidget's size, and the fact that he lives in a pet-food shop – in North Shields – somehow be connected?

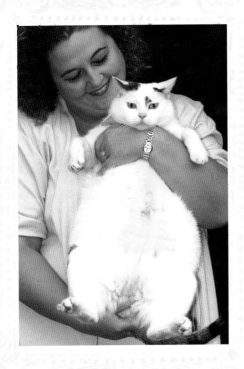

FIDGET

Fidget still weighs a hefty 18lbs
even after dieting.

FiDGeT

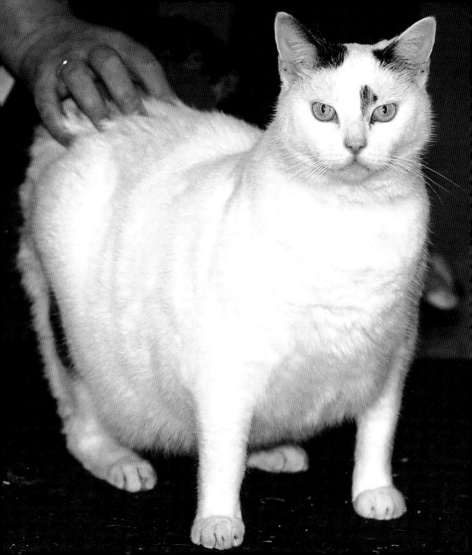

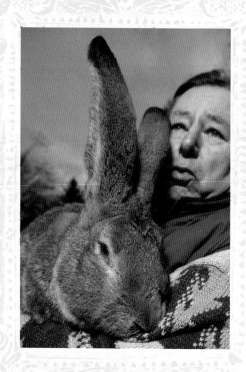

KARL

KARL

and his Rabbits

*K*arl Szomolinsky breeds rabbits the size of dogs – including a 23lb floppy-eared titan called Robert. Here is Karl with one of Robert's offspring.

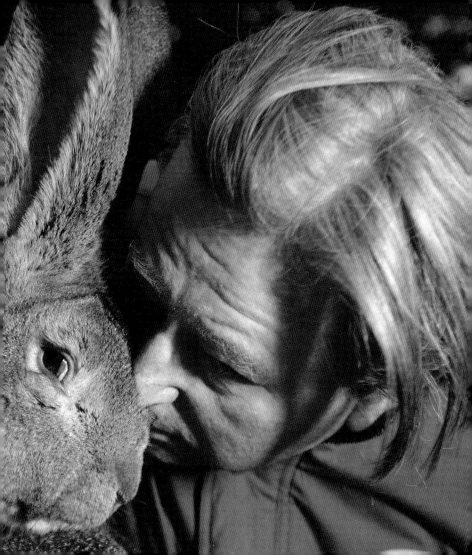

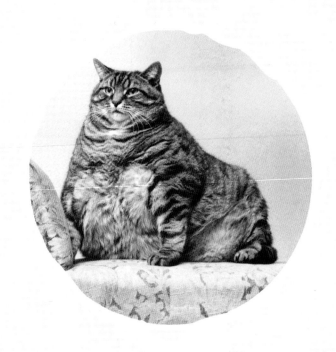

JOSEPH

JOSEPH

the Cat

Joseph – a fat cat in every sense of the word – was left a large sum in his owner's will, who wanted to make sure he didn't go hungry. It looks like he didn't.

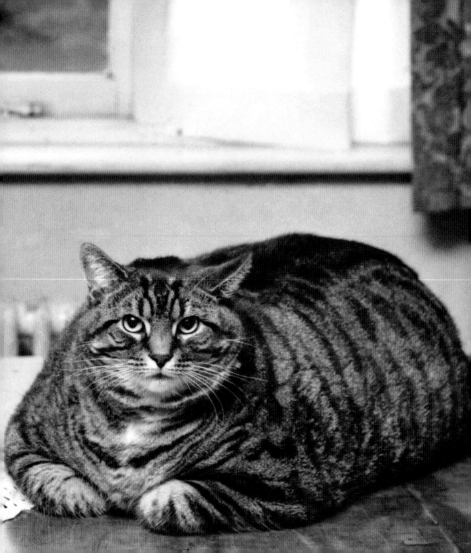

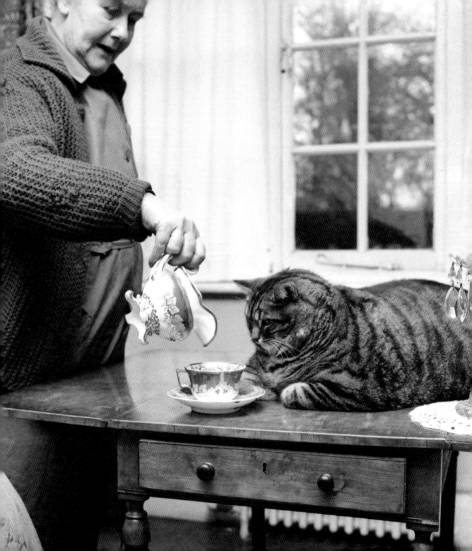

AMY

the Rabbit

Amy, a three-stone four-foot-long rabbit, hails from the West Country

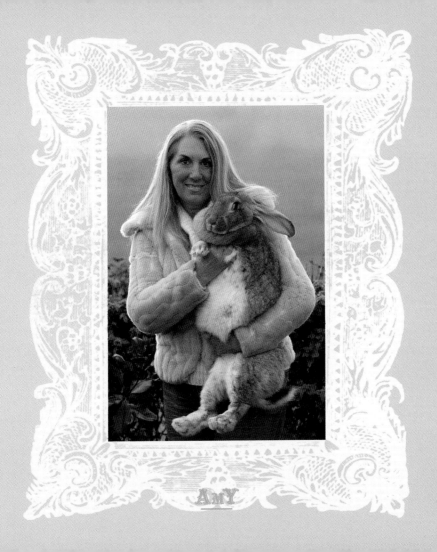

AmY

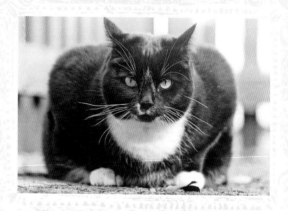

SOOTY

the Cat

S ooty, a cat from Scarborough in North Yorkshire, was put on a diet after he reached 26lb – nearly two stone. Molly Oliver, his owner, said: 'The last straw was when he got stuck in the catflap and could-n't go outside. Although he loves meat, I feed him exactly the same amount as any other cat. I think some people have been leaving food out for him."

SOOTY

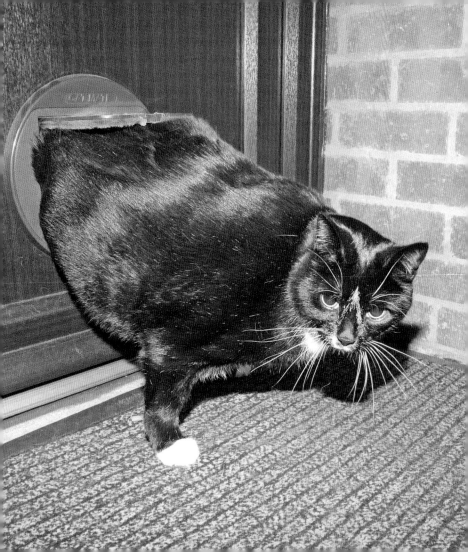

←◄

Sooty is now able to fit through
the catflap, as he demonstrates here.

<u>**SOOTY**</u>

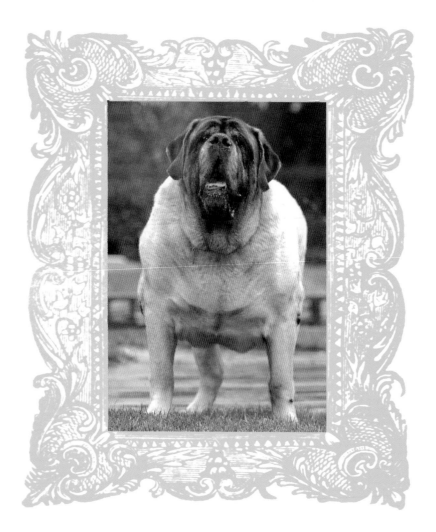

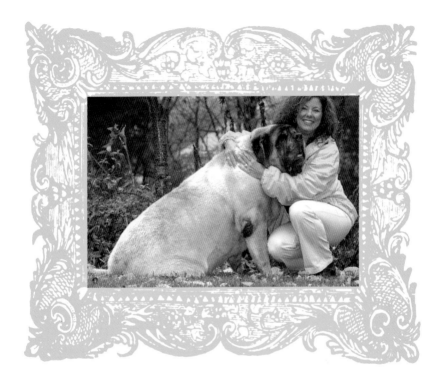

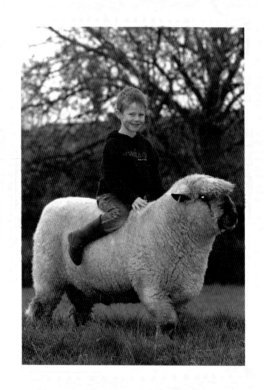

CRIFF

GRIFF

the Sheep

Griff the giant sheep is from East Yorkshire. He's thought to be the biggest sheep in England.

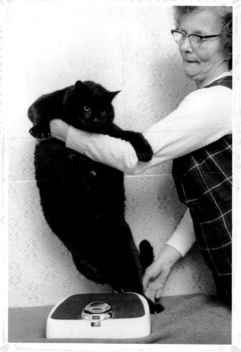

TiBBY

TIBBY

the Cat

Getting a cat on the scales is never easy – as Hilda Dodd, from Kent, demonstrates in 1963. Eventually she found that her cat Tibby weighed 28lbs.

DANCING STAR the Rabbit

At 26lb Dancing Star is a very large rabbit indeed.

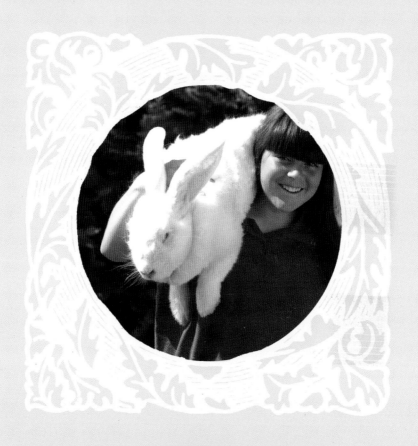

DANCING
STAR

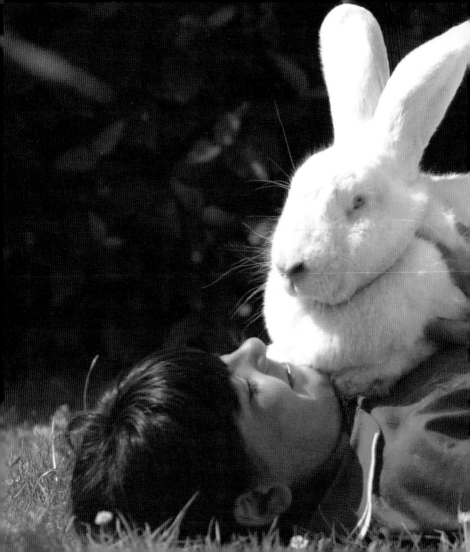